FOR LOVE OF THE DARK ONE

Songs of Mirabai

FOR LOVE OF THE DARK ONE

Songs of Mirabai

Revised Edition

Translated by Andrew Schelling

Hohm Press
Prescott, Arizona
1998

Some of these poems have appeared in the following journals:
*Dark Ages Clasp the Daisy Root, Darshan, Notus, Parabola,
Shambhala Sun.* Some have appeared in *Holy Fire: Nine
Visionary Poets and the Quest for Enlightenment*
(HarperCollins), *The Erotic Spirit* (Shambhala), and in *The
India Book: Essays and Translations from Indian Asia*
(O Books). My thanks to the editors.

Layout and Design: Mel Lions; Jaye Pratt at Alpha Cat Design,
San Diego, California.

Cover Design: Kim Johansen

Library of Congress Cataloging-in-Publication Data:

Mīrābāī, fl. 1516–1546
 For love of the dark one : songs of Mirabai /
translated by Andrew Schelling. -- Rev. ed.
 p. cm.
 ISBN 0-934252-84-X (pbk.)
 1. Mīrābāī, fl. 1516–1546 -- Translations into
English. I. Schelling, Andrew. II. Title.
PK2095.M5A6 1998
891.4´312--dc21 98-30082
 CIP
Hohm Press
PO Box 2501
Prescott, Arizona 86302
800-381-2700; fax: 520-717-1779
pinedr@goodnet.com
http://www.booknotes.com/hohm/

This book was originally published by Shambhala Publishers,
Boston, Massachusetts, 1993, under the same title. The original
ISBN: 0-87773-872-6

For Bertha Tigay Saposs

and Althea Rose Schelling

*M*ira shattered the manacles
　　of civility, family, and shame.
　　A latter day gopi, she made love explicit
　　for the dark Kali Yuga.
　　Independent, unutterably fearless,
　　she sang her delight for an
　　amorous god.
　　Scoundrels considered her treacherous
　　and ventured to kill her,
　　but draining like nectar the poison they sent
　　she came forth unscathed.
　　Striking the drumskin of worship
　　Mira cringed before no one.
　　Family, civility, gossip—
　　she shattered the manacles.
　　She sang praise to her lord who lifts
　　mountains.

　　　　　—Nabhadas
　　　　　from the *Bhaktamala* (ca. 1600)

Acknowledgments

\mathcal{I}'d like to thank Kevan Brown, who accompanied me early into Mirabai's poems; Michael Golston, who raided libraries for books to which I had no other access; Kabir Smith, who showed up with a dictionary just when needed; and Anne Waldman who read the manuscript repeatedly, and became one of its midwives.

\mathcal{F}or the singers, ancient and modern, most of them women and without whom these poems would not have survived the centuries, three times I touch my head to the ground.

Contents

Preface to the Second Edition

*S*ix years ago with the prodding of a few friends I put
this book together. At the time its publisher felt it best not
to include any of Mirabai's original language, lest the
bristling phonemes of old Rajasthani chase away folk who
might otherwise enjoy the book. Today it's clear that
increasing numbers of Americans recognize India once
produced the best love songs on earth. A small but serious
group are learning the languages, playing the music, con-
sidering the art. The principal change I've made in this
new edition is to include the few first words of each
song—words which in the song tradition, and in the
printed books, serve as titles. These should help locate the
originals for anyone wanting to go deeper.

India is the last large culture on the planet with its old
mythologies utterly alive, a huge dizzying weave of stories,
poems, musics, full of strange antithetical characters.
Nobody knows how far back in prehistory Krishna first
appears, but across South Asia you meet him every day.

Krishna the infant candy-thief, Krishna the love-hungry youth, Krishna the able charioteer, Krishna the imponderable deity.

When the first atomic bomb went off, J. Robert Oppenheimer looked up and thought of Krishna. Like Arjuna on another battle front he quavered, "as though the flash of a thousand suns were to rise all at once in the sky." Krishna is a name that can be given to powerful dangerous forces. Daniel Ellsberg tells me engineers on the Manhattan Project recited another verse, also from *Bhagavad-gita*. It is Krishna's—

I am Time, mighty world-destroyer,
arisen to annihilate everything.
Even without you, these warriors in battle formation
will cease to exist.

It helped keep the nuclear scientists sane — this idea that the casualties of war are already dead, and that human life is measured out by a vast and inscrutable godhead who commands the fate of armies.

Mirabai's Krishna looks slighter. A thin boy, negligent, sometimes gone like a hermit. Unreliable, headstrong, kind of a trickster. Combative armies are the last thing to hold his attention. But there's a paradox here. Flip the whole thing over and it appears there's a different power— maybe a grander one—in acknowledging what tender omnivores we are, subject to love and pain, hard grief, fleeting joy. We celebrate these things in songs and poems,

even though warriors are arming themselves and setting out for the annihilation of worlds. Maybe the more desperate things get, the fiercer the human instinct for love. This is what will keep Mirabai's poetry vivid into the next century.

A century, let's hope, a bit less world-destroying than the last one has been.

Boulder, Colorado
February 1998

Introduction

*T*here exists in poetry a tradition of outriders or night cadres, of nomads, exiles, and rebels of song. Throughout history, within every literate culture, poets belonging to this lineage have emerged to articulate a brave and defiant opposition to unjust social orders: the unequal distribution of wealth, religious persecution, oppression of women, racial discord, and aggressive military exploits. Marauding armies, abusive government agents, exploitative churches—these come and go across the planet like storm clouds, and in their passage cause grievous suffering. Somehow the poets who sing within the oppositional tradition stay with us.

Mirabai, born a princess in 1498 in the region of Rajasthan, belongs to this outspoken lineage. Today she is the most renowned poet of India, her songs recited from memory by Hindus, Muslims and Sikhs. Popular versions appear on the radio and liven the cinema. In Asia and the West alike, scholars classify her verse as "devotional,"

discussing it in theological terms or drawing upon it to elucidate religious beliefs that have hung on since her day. But this is a woeful diminishment of Mirabai's art. It in no way explains her electrifying popularity, which spans the Indian subcontinent, observing no boundary of language, caste, or religion.

As a poet, Mirabai strikes us moderns as impressively fearless, passionate, defiant, and clear-eyed. Her peers are not just the saintly poet-mystics of India; nor does she belong exclusively to that set of eremitic religious figures that appear throughout history to recount spiritual visions in metrical verse. Mirabai belongs intimately to a more far-flung company: that set of poets who during periods of oppression, war and social unrest, cast everything into the fire, that they may pursue a dignified and unblinkingly honest human life. A life blazing with spirit and intellect. Among poets she keeps company with the women troubadours of thirteenth-century Provence, with Sor Juana Inés de la Cruz of New Spain. In the twentieth century with Anna Akhmatova and Nadezhda Mandelstam—all of them women in brave conflict with the powerful men of their day, each of them salted with poetic fire.

≈

Most accounts agree Mirabai was born about 1498 into a Rajput clan, the Rathors, who ruled the city of Merta and it surrounding villages. Her great grandfather on her father's side, Jodhaji, had founded the city of Jodhpur, still

one of Rajasthan's centers of handcraft and trade. Her grandfather, Dudaji, had conquered the city of Merta along with 360 surrounding villages, and gave Mira's father, Ratnasingh, twelve of them, including Kudki where Mira was born into a small but lavishly equipped fortress.

It was a troubled time politically. Warrior clans of astonishing ruthlessness fought over territory and trade. They regarded each other with too much suspicion to unite against the Moghul rulers who kept a seat of Empire in Delhi. They could, when threatened by foreign armies, forge a rough temporary alliance and fight fiercely alongside one another. But unsteady alliances kept everyone edgy. If you're ever in Rajasthan and visit any of the old Rajput palaces, ask to see its armory of inventive and gruesome weapons—blades and cudgels, cutters and lances, enormous scissors that slash out an enemy's entrails. You'll get some idea how tenaciously warfare and battlefield honor gripped the imaginations of the ruling clans, and how hungrily they carved up the territories among themselves.

The Rajputs exact a strict loyalty from their wives and sisters. Among the exogamous ruling clans, which pride themselves on the sexual virtue and exaggerated modesty of their women, marriage had one principal objective: the securing of military alliances. So, following the day's custom, Mira's family prepared to marry her into a neighboring clan, the Sisodiya Rajputs of Mewar, in order to stabilize local politics and perhaps avert a blood feud. As a princess, born to privilege and being readied for a

politically consequential marriage, Mira would have been exactingly tutored in a variety of arts. She studied music, poetry, dance; perhaps theatre and painting. Judging by the savviness of her song, how it rings with the verse of the past, I suspect a good deal of the old Sanskrit language with its classical poetry got into her ear. She could ride and probably shoot a bow. As for the martial arts, she would have known them intimately—if only by observing the far-out arrogant swagger of the family warriors she grew up with. These were wild-minded people.

Legend has it that as a small child Mira answered the palace gate to give food to a *sadhu*—a wandering religious beggar—who whispered a few words in her ear and pushed into her fist a tiny statue of Krishna which she treasured for the rest of her life. In a few of her songs she remarks how she received "the words" of a guru. Since there exists no account of her having ever taken a teacher or undergone formal instruction, tradition ascribes to those few whispered words all the religious training she needed. Who was the *sadhu?* Nobody knows. But one day Mira in girlish curiosity pestered her mother about her future husband. To whom was she to be married? (A Rajasthani girl of her pedigree would know this is the great event her childhood prepares her for.) Her mother in jest or exasperation swept her hand toward the little Krishna image. "To him. Krishna will be your groom." From that moment Mira considered herself married to Krishna, whom she addressed by the tender name *Shyam*—Dark One.

Mira about the age of twenty arrived at the palace of

her family by marriage, wed to Bhojraj, son of the fear-
some warrior Rana Sanga. By customary law, as a bride
she belonged to the Sisodiyas, and in effect was their prop-
erty. In her songs when she twists things around and
speaks of being sold off at market it is no simple
metaphor. She felt the raw humiliation arranged marriage
meant for a woman. She had a reputation for beauty, for a
cultivated poise, for artistic and philosophic learning, for
pride. But no one was prepared for the disturbance she
would provoke in her demand for artistic, spiritual, and
sexual freedom.

The equally proud members of the Sisodiya clan were
Shaktas—worshippers of the Goddess—and by tradition
Mira was expected to assume their style of worship. More
precisely, by the old institution of *suhag*, her religious
duties were to be discharged in unquestioning service to
her husband. She simply refused to carry them out. One
account tells how she dutifully touched her mother-in-
law's feet but lightly walked past their image of Kali, say-
ing she'd long been on most intimate terms with the true
Lord, and could not bow to a lump of stone.

Compounding the indignity, Mira insisted that Shyam,
pledged to her lifetimes ago, was her true husband.
Shyam, the dark-skinned, mischievously seductive, adoles-
cent flute-playing form of Krishna, whose cult had devel-
oped in village and marketplace, well outside the stiff
guidelines sanctioned by theologians and officious priests.
Mira, the stories tell us, refused to sleep with her husband.
Details about Bjojraj remain sketchy—only in recent years

have scholars managed to get clear who he was. Probably a bit weak-minded for a warrior, he scarcely figures in the Mirabai legends. It's likely he died on the battlefield shortly after their wedding.

Mira refused to wear widow's weeds though, and rejected every convention of widowhood. She took to singing and dancing, dedicating these acts to Shyam—whom she addressed in the most intimate terms. Her songs plead and adore, badger, scold, weep. Overstepping all propriety she would descend from the Sisodiya palace into town, where she consorted with sadhus and low-caste *bhaktas* (worshippers) in local temples. Her in-laws were enraged. Vikram Singh, a brother-in-law who had succeeded his father as clan leader and prince, suspected her *sadhu* compatriots as spies—engaged by rival clans or hostile military powers.

This may not have been as far-fetched as it sounds. Wandering mendicants, free to crisscross borders on pilgrimage without interference by local authorities, made perfect agents. Centuries later the British used them extensively for espionage and map making. But Vikram Singh, in a reflex of paranoia that is most certainly unjustified, imagined Mirabai's songs to be coded messages detailing military information. Legend holds that after failing to subdue Mira by posting a guard at her door in the palace, Vikram Singh and his mother attempted on three occasions to kill her.

First they offered her consecrated water, saying it had been used to wash the feet of a Krishna idol; they'd in fact

laced it with poison. In one of her most famous songs—
pad gunghru bandh—Mira declares she "drained the cup
without missing a step." Her in-laws then sent her a
wicker-basket of fruit, a deadly black cobra under its lid.
But when Mira opened the basket she found a *shalgram*—
one of the black fossilized ammonites that litter the bed of
the Gandaki River, which worshippers recognize as a man-
ifestation of Vishnu. Her in-laws in a final attempt on her
life forced her to lie on a bed of razor-sharp spikes.
Somehow the spikes as she lay on them turned into flower
petals. Three attempts on her life, three times, say her
admirers, Mira's god interceded to save her. Or as the
more cold-eyed among us suspect, allies in the palace
replaced each lethal substance with an inert substitute.
Certainly the day's politics were complex—agents and
counter-agents threaded the countryside. And Mirabai
would have been a precarious target—her songs, her
blatant disregard for convention, her razor-tongued
defense of the downtrodden—these had earned her some
notoriety as a quite reckless saint who treated the poor
and outcaste with memorable tenderness. One also sus-
pects her old Rathor family ties remained considerable.

Trust in god but keep your powder dry. Mira's god
might keep a close eye out for her, but Mira knew the next
step. She quickly departed from Sisodiya territories, took
to the road on foot, fled the excessive pride and wealth
that shackled her, the calculating in-laws, the mediocre
religion, and the subservient widow's role imposed on her.
The rest of her life she spent wandering the forests,

villages, highways and temples of north India.

She crisscrossed northwestern India repeatedly, treading the roadways of Rajasthan and Gujarat, pursuing her elusive Krishna through the forests and villages he was rumored to frequent. In song after radiant song she calls him Shyam—Dark One, "the Raven Colored." The name evokes Krishna as an irresistible figure—mysterious, unreliable, ravishing the heart with his youthful beauty, devastating it with infidelity. Breathing across the soft bamboo flute he carries, he bewitches the cow-herding girls of the towns around Madhuban, who slip from their homes after dark, stealing away from husbands and children to enjoy a night of dancing and rapturous, adulterous love. Mira calls her Dark Lord by other names also. These appear in the poems, each illuminating some aspect of his quixotic character or the tales that go with him: Giradhar, Lifter of Mountains; Manamohan, Enchanter of Hearts; Hari, the Abductor. Is he half divine? Half human? In Mirabai's poem we're never quite sure. Just that he's always a few villages ahead of her, maybe flirting or sleeping with some other woman.

At this point the accounts of her become complex, contradictory, embellished by numerous storytellers. Mira's wanderings take her again and again into the Vaishnavite grounds known as Madhuban, Forest of Honey, or maybe Forest of Sweet Delights. It seems her songs passed among *bhaktas* like quicksilver, and caught on throughout her homeland, particularly among women. Some are certain she enjoyed fame in her lifetime and

cycles of legend enveloped her. It's clear why. Unlike most of the renowned poets who sing their devotion to some form of the god Vishnu—men like Surdas and Tulsidas come to mind—Mira's songs hold no subtle theological arguments. They are constructed on no secret formulas, do not toy with elaborate metaphor. They cut to the quick—amorous, hungry, full of ecstasy, or tossed with despair. This to my mind is what sets her apart from the well-known men who were her contemporaries: in her song she reanimates India's old tradition of love poetry, and recklessly sweeps it up into religious conviction.

Tales of Mirabai still circulate. One recounts how, on reaching the vicinity of Vrindavan, the woodlands sacred to worshippers of Krishna, she encountered the famous theologian Jiv Gosvami. This redoubtable scholar and fearsome ascetic denied her access to one of Krishna's temples because she was a woman. Mirabai shamed him with the words, *"Are not all souls female before god?"* Jiv Goswami bowed his head and led Mira by the hand into his temple.

There is the account of an unknown *sadhu* who joined the company Mira was traveling with. This man insisted the Dark One had appeared in a vision, instructing him to seek out Mirabai and make love to her. Approaching Mira, he demanded she prove her devotion by complying with dark Krishna's command. Mira turned on her heels lightly and led him to the city square where a crowd of *bhaktas* had collected to sing. She bundled an armful of robes into a bed in the midst of the crowd and scattered flowers across it. Announcing to the curious assembly that she was

intended to honor her lord, she loosened her gown. "We shall honor the Dark One's directive," she smiled. "Come, you are among friends." Surrounded by Mira's watchful companions, the *sadhu* grew pale, started to tremble, then threw himself at Mirabai's feet and begged her forgiveness. It is said he became a resolute follower of the *prem-bhakti-marga* (path of love and devotion), and one of Mirabai's staunchest admirers.

Stories like these, coupled with the elegance, honesty and incandescence of Mirabai's songs, spread throughout India. Tradition numbers the great Moghul emperor Akbar among her admirers, as well as his court musician Tansen, who according to Herman Goetz may have drawn from her songs some of the elements with which he revitalized North Indian, or Hindustani music, and gave it the shape known today.

By her fiftieth year Mira had come to reside in the coastal Gujurat city of Dwarka. In Dwarka stands the Ranchhorji temple, one of India's four cardinal destinations of pilgrimage, the sea beating against its rear doors. In his biography, Goetz suggests Mira set up a soup kitchen and hospice alongside the temple where she would attend to the poor. Back in her homeland the Sisodiya clan meanwhile had suffered a series of devastating military reversals. One account says 13,000 women in Sisodiya territory, learning their husbands had been lost in battle, collectively immolated themselves on a pyre rather than await an expected humiliation by enemy forces. Rumor flared through the region that the defeats had come as

divine retribution for Sisodiya mistreatment of Mira. Confronted with a possible revolt in their domains, Mira's in-laws decided to bring home their princess, hoping to manipulate Mirabai's reputation in order to legitimize their rule in the eyes of the populace. They dispatched a crew of civic officials and brahmins to Dwarka to fetch her.

The envoy located her at the soup-kitchen clinic she'd founded, and threatened to starve themselves to death if she did not return with them. It was a blatant misuse of their authority, knowing Mirabai would not take on the karma of their deaths.

Faced with the prospect of a return to the indignities of the Sisodiya household, the wealth that held no interest, the title she'd rejected once and for all as useless, Mira requested and was granted a final night alone in the Ranchhorji temple, which housed a favorite image of her god. Was the Ranchhorji temple guarded that night? Could someone have slipped out the back door and into or across the sea? The stories are mute. But in the morning when the envoi forced open the locked gates, all that remained—draped across the feet of the deity—were Mirabai's robe and her hair.

~

Echoing down the centuries, Mirabai's songs ring with familiar themes. Their tone and language sound neither quaint nor provincial. She set upon the issues of her day—grim fundamentalist religion, despotic military

rulers, the outrages of caste, mistreatment of women—
and whirled them up into personal imperatives of erotic
and spiritual hunger. Like gospel songs in America, her
poems articulate a precise disaffection, a stance of refusal
towards the unjust and the abusers of power. Devotional,
yes—but explosively so—their wild generosity condemn-
ing the hypocrisies and violence of "good civic sense."
That Mira used her own life to revitalize a poetic form at
which India has always excelled, the love song, makes her
all the more remarkable.

The earliest classical poetry appeared in India nearly
1500 years before Mira's birth. The Prakrit *Gatha-Sattasai*,
compiled by a King Hala (ca. 200) of the Satavahana
Dynasty, contains 700 two-line poems, most of them
explicitly amorous. Cited by Indian scholars and poets over
the centuries as a standard of excellence, the *Sattasai* poets
set the tones, rehearsed the gestures, and gave voice to the
passions each generation of poets in India has renewed.
The near intolerable longing for an absent lover; the thrill
of braving perilous landscapes or the censure of neighbors
and relatives in order to meet a beloved in some wild
trysting place; the appearance of rainclouds marking the
end of India's insufferably hot, dusty "riot season"; the
quickening of parched vegetation and sluggish wildlife by
monsoon rain. Add to these the cry of the peacock, the
song of the Indian cuckoo, a heart ravaged by a longing
that is spiritual as much as erotic, and you have the ele-
ments Mirabai worked in her poetry.

One of the themes that repeatedly crops up in India's

old verse—a tradition that emerged in a day freer and more friendly towards women than Mira's—was the light and delicate depiction of girls who've set out for the adventures of illicit love. The *asati*, or faithless wife, makes her way through many old poems. A heroine too wild-eyed, rapturous and proud to abide by the narrow conventions of an arranged marriage (often to an older man she might scarcely know), too defiant to labor in the kitchen while her youth vanishes, she is attended by dignity and good humor. The poets of classical times admired and celebrated the spunk shown by these impatient, barebreasted child-brides as they sought out hidden groves by the river, or slipped along roadways made perilous by moonlight. Mira, in a less tolerant age, toyed with this theme in her poems. One should not underestimate her boldness. This was Rajasthan, a region that exacts a particularly docile obedience from its women.

In other moods, Mira poses as a long-suffering and devout woman, pledged to a single lover despite his persistent neglect. Yet the person she calls "true lord" is decisively not her husband. He is a god, a trickster, a wandering lover, a cold-eyed *yogin* who travels the centuries, endlessly youthful. Mira declares herself born again and again in order find him, and to consummate her desire. This defies another convention. For a *yogin* is a spiritual renunciant, a person who rejects not only marriage but the whole range of sexual attachment it's founded on. Mira mocks this outsider status—in India its own sort of counter-establishment institution—knowing

the hypocrisies it generates. In several poems she accounts herself an irrepressibly amorous *yogini*, woman renunciant, pasting her limbs with ash, cow-dung in her hair, dressed up in tatters—scouring the centuries to sleep with her lover. Even her asceticism rings with eroticism.

Nobody knows how many songs Mira composed. A recent survey of those circulating India under her name came up with 5,197. The most knowledgeable estimates consider three or four hundred authentic. Today a number of these belong to the repertoire of any classical Hindustani singer of note. They also belong to an undiminished folk tradition. Wander the rural villages, go into the cities, anywhere dark Krishna remains an animate presence, and you will hear Mira's poetry—in courtyards, on the concert hall stage, along highways, through markets. I myself have sat all night during the rainy season in a small temple in Rajasthan while a crowd of people sang her poetry to a few finger cymbals, a harmonium and a drum. The scene has hardly changed since Mirabai's day.

⌇

Some declare that Mira's verse kept pace with the centuries only on the *sadhu*'s lips. Others tell of a mysterious girlfriend, Lalita, one of her childhood handmaids, who followed her into exile. Lalita, they say, shadowed her mistress from town to town, transcribing the songs into a great notebook. Records from the Ranchhorji temple at Dwarka speak of this notebook, or a copy. But it seems to

have vanished when a Moslem warlord plundered the temple sometime in the seventeenth century. The earliest known manuscript post-dates her death by 200 years. For nearly five hundred years an oral tradition has transmitted the songs, and this seems appropriate. After all, part of their popularity is that for all the musical sophistication their outspoken passion is never more than a step or two removed from India's folk song. Perhaps, as some have suggested, in a country where through most of history writing has been the preserve of men, it was the women who kept Mirabai's songs alive, passing them across the generations from mother to daughter.

While there have been several modern attempts to compile an authoritative edition, the standard or commonly used one is the *Mirambai ki Padavali*, compiled by Parashuram Caturvedi. Its most recent revision appeared in 1983. The *Padavali*, or verse-compilation, presents lyrics to 202 songs reasonably attributable to Mirabai, and another eighteen of dubious authorship. In preparing my translations I have worked mostly from Caturvedi's book, though I rarely keep to his sequence, as he grouped songs by raga, or musical mode.

Occasionally certain lyrics, whether they refer to specific events in Mirabai's life or are sung to the same raga, seem to belong together. But a fine impenetrable haze covers Mirabai's life, and I've resisted putting her songs in some order that reduces them to biography. Enough people have done that. Doubtless many elements of her life glimmer through the words. But she was a learned

xxviii

woman, adept at both classical and folk traditions, and the lyrics belong to a 2000-year tradition of Indian love poetry, a tradition that draws on the old simplicity of image, the passionate gesture, and a range of plants, animals, and weather patterns known throughout India. A talented singer will shuffle them into whatever order best fits the mood of the day.

For my own understanding of Mirabai's art I have gone every time to such singers. They are the ones, not the scholars and theologians (though these have performed fine and indispensible work), who risk themselves on each song. They are the ones negotiating the delicate griefs and savage ecstasies you arrive at through Mirabai's music. In gratitude to them I've included at the back of this book a discography of Mirabai songs that have found their way into my hands. I urge those who wish to know more about Mira to go to the singers.

FOR LOVE OF THE DARK ONE

Songs of Mirabai

paga bāndha ghūṃgharyāṃ ṇācyārī

B inding my ankles with silver
 I danced—
 people in town called me crazy.
 She'll ruin the clan
 said my mother-in-law,
 and the prince
 had a cup of venom delivered.
 I laughed as I drank it.
 Can't they see?
 Body and mind aren't something to lose,
 the Dark One's already seized them.
 Mira's lord can lift mountains,
 he is her refuge.

.

mhāre dere ājyo

*C*ome to my bedroom,
 I've scattered fresh buds on the couch,
 perfumed my body.
 Birth after birth I am your servant,
 sleep only with you.
 Mira's lord does not perish—
 one glimpse of the Dark One
 is all she requests.

.

māī mhārī harī hūṃ

Sister, the Dark One won't speak to me.
 Why does this useless body keep breathing?
 Another night gone
 and no one's lifted my gown.
 He won't speak to me.
 Years pass, not a gesture.
 They told me
 he'd come when the rains came,
 but lightning pierces the clouds,
 the clock ticks until daybreak
 and I feel the old dread.
 Slave to the Dark One,
 Mira's whole life is a long
 night of craving.

.

mhāṇe cākara rākhāṃjī

𝒯am your slave.
 Bind me in tethers, Mira's your slave.
 She wakes up at dawn,
 sits in the garden,
 haunts the pathways of Vrindavan forest
 making up ballads.
 Fever, memory, craving,
 birth after birth they come with me.
 I slip on a saffron robe
 hoping to see you.
 Yogins come to Vrindavan to know oneness,
 hermits perform terrible spells,
 holy men come to sing gospels—
 but Mira is deeper, lord,
 and more secret.
 She waits with a ruined heart every night
 by the river
 just for a glimpse.

For Love Of The Dark One

.

sāṃvariyo raṅga rāchāṃ rāṇā

He has stained me,
 the color of raven he's stained me.
 Beating a clay
 two-headed drum at both ends
 like a nautch girl I dance
 before sadhus.
 Back in town I'm called crazy,
 drunkard, a love slut—
 they incited the prince
 who ordered me poisoned
 but I drained the cup without missing a step.
 Mira's lord is the true prince,
 he stained her the color of raven,
 birth after birth
 she is his.

.

thāmṇe kāṃī kāṃī bol sunāvā

𝒟ark Friend, what can I say?
This love I bring
from distant lifetimes is ancient,
do not revile it.
Seeing your elegant body
I'm ravished.
Visit our courtyard, hear the women
singing old hymns.
On the square I've laid
out a welcome of teardrops,
body and mind I surrendered ages ago,
taking refuge
wherever your feet pass.
Mira flees from lifetime to lifetime,
your virgin.

· · · · · · · · · ·

bhaja maṇa charaṇa kaṃval

O Mind,
 praise the lotus feet that don't perish!
 Consider all things
 on heaven and earth—and their doom.
 Go off with pilgrims, undertake fasts,
 wrangle for wisdom,
 trek to Banaras to die,
 what's the use?
 Arrogant body just withers,
 phenomenal world is a coy parakeet
 that flies off at dusk.
 Why throw a hermit robe over your shoulders—
 yellow rag yogins
 are also bewildered,
 caught every time in the birth snare.
 Dark One, take this girl for your servant.
 Then cut the cords and
 set her free.

.

muraliyā bājā jamanā tīr

𝒟 own by the river a flute!
 O ruined heart,
 what is conviction
 that a flute player dissolves it?
 Dark waters, dark trousers
 and Krishna darker than ever—
 one bamboo flute note
 so pure it drives Mira out of her mind.
 Lord, this stumbling body,
 free it from torment.

.

jogī mata jā mata jā

*Y*ogin, don't go—
 at your feet a slave girl has fallen.
She lost herself
 on the devious path of romance and worship,
 no one to guide her.
Now she's built
 an incense and sandalwood pyre
 and begs you to light it.
Dark One, don't go—
 when only cinder remains
 rub my ash over your body.
Mira asks, Dark One,
 can flame twist upon flame?

.

jogī mhāṃne darasa diyāṃ

*Y*ogin, a single glimpse
and I'd be exultant.
But life on this crazy planet is torment,
day and night torment.
Mad, raked by separation—
drifting from country to country—
look at Mira's black hair
 it's turned white.

.

akhayāṃ taraśā darasaṇa pyāsī

*H*ungry eyes and I
 crave him—
 O friend, days shuttle past
 while I rage out my lyric heart
 on the highway.
 A cuckoo up on a perch
 torments my ear with its song.
 Ugly words come from the citizens, they make
 me the butt of their jokes.
 Thus Mira is sold on the market,
 into the hands of her Dark One,
 birth after birth.

.

mhāṃ giradhara āgāṃ nācyārī

*D*ancing before him!
 To whirl and to spin!
 charming his artistic passions
 testing old urges—
 O Dark One beloved, I bind on my anklets,
 true love is drunk.
 Worldly shame! family decorum!
 who needs such virtues?
 Not for an instant, one eyeblink,
 do I forget him—
 he has seized me and stained me,
 that Dark One.

.

jagamāṃ jīvaṇā thoṛā

Life on this planet is fragile,
 why take up a burden?
 From mother and father
 come birth,
 but from the font of creation comes karma.
 People waste life,
 heaping up merit like they're buying and selling—
 it's pointless.
 I sing out the raptures
 of Hari, go into passions with sadhus,
 nothing disturbs me.
 Mira says—it's your power Dark One,
 but it's me who crosses
 the limits.

.

baraji rī mhāṃ syām biṇā na rahyāṃ

*M*y Dark One,
 they've placed him off limits—
 but I won't live without him.
 Delighting in Hari,
 coming and going with sadhus,
 I wander beyond reach of the world's snare.
 Body is wealth
 but I just give it away—
 this head was long ago taken.
 Full of rapture
 Mira flees the jabbering townsfolk,
 going for refuge
 to what cannot perish—
 her Dark One.

.

nindaṛi āvāṃ ṇā sārāṃ rāt

*A*nother night without sleep,
thrashing about
until daybreak.
Friend, once I rose
from a luminous dream, a vision
that nothing dispels.
Yet this writhing, tormented self
cries out to meet
her Lord of the outcast.
Gone mad, gone crazy,
mind and senses confused with unspoken secrets—
Oh the Dark One
holds life and death in his hands,
he knows Mira's anguish.

.

bādal dekhā jharī

𝒶louds—
 I watched as they ruptured,
 ash black and pallid I saw mountainous clouds
 split and spew rain
 for two hours.
 Everywhere water, plants and rainwater,
 a riot of green on the earth.
 My lover's gone off
 to some foreign country,
 sopping wet at our doorway
 I watch the clouds rupture.
 Mira says, nothing can harm him.
 This passion has yet
 to be slaked.

rī mhāṃ baiṭhyāṃ jāgāṃ

*F*riend,
 though the world sleeps
 the abandoned go sleepless.
 From inside the palace
 counting the planets
 someone threads teardrops onto a necklace.
 The abandoned go sleepless.
 Night has suddenly
 vanished and Mira,
 Mira has missed the hour of pleasure,
 missed the Dark One who
 eases her pain.

.

aisi lagan lagāi

*Y*ou pressed Mira's seal of love
then walked out.
Unable to see you
she's hopeless,
tossing in bed—gasping her life out.
Dark One, it's your fault—
I'll join the yoginis,
I'll take a blade to my throat in Banaras.
Mira gave herself to you,
you touched her intimate seal
and then left.

.

sāṃvaro mhāro prīta

𝒟 ark One
all I request is a portion of love.
Whatever my defects,
you are for me an ocean of raptures.
Let the world cast its judgments
nothing changes my heart—
a single word from your lips is sufficient—
birth after birth
begging a share of that love.
Mira says, Dark One—enter the penetralia,
you've taken
this girl past the limits.

cālāṃ vāhī desa prītama

*G*o! Go to that land
 where a glimpse of the Dark One
 is had.
 Give me the word,
 I'll wear a red sari,
 give me the word, I'll dress up in hermit rags;
 one word, I'll lace pearls
 through the part in my hair,
 or scatter my braids into dreadlocks.
 Mira's lord rules the true court,
 she says, go,
 go where he dwells.
 Then heed the songs of your
 king.

.

naiṃda nahiṃ āvai

*A*nother night
 sleepless,
 tossing in bed,
 reaching for someone not there.
 Tossed darkness
 life wasted
 a tossed mind convulsing all night.
 Another night sleepless and then,
 the bright dawn.

.

mero beṛo lagājyo pār

Guide this little boat
 over the waters,
 what can I give you for fare?
 Our mutable world holds nothing but grief,
 bear me away from it.
 Eight bonds of karma
 have gripped me,
 the whole of creation
 swirls through eight million wombs,
 through eight million birth-forms we flicker.
 Mira cries, Dark One
 take this little boat to the far shore,
 put an end to coming
 and going.

.

piyā ab para ājyo mere

℞emember our pledge,
 that you'd come to my cottage?
 I'm strung out,
 I stare down the road
 and strain for a glimpse of you.
 The hour we set
 came and departed.
 I sent a messenger girl
 but Dark One, you tossed out the message
 and deflowered the girl.
 Days I don't see you are torment,
 Mira knows you're with
 somebody else.

.

barasāṃ rī badariyā sāvan rī

*T*hick overhead
 clouds of the monsoon,
 a delight to this feverish heart.
 Season of rain,
 season of uncontrolled whispers—
 the Dark One's returning!
 O swollen heart,
 O sky brimming with moisture—
 tongued lightning first
 and then thunder,
 convulsive spatters of rain,
 then wind chasing the summertime heat.
 Mira says Dark One,
 I've waited,
 it's time to take my songs
 into the street.

.

sāṃvaliyā mhāro chāya

*M*y lover's shadow
　　falls on foreign terrain,
　　not a note
　　to say where to meet him.
　　I cropped my hair,
　　stripped off my jewels and my gown,
　　threw on this beggar's robe,
　　and it's your fault.
　　My lover's shadow darkens
　　some other country
　　while I wear out my feet on the roads.
　　When Shyam left her bed
　　Mira's life became wreckage,
　　a ruin from
　　birth.

them mata barajāṃ māi ṛi

𝒟 on't block my way, friend,
I'm joining the sadhus.
The Dark One's image sits in my heart,
now nothing gives solace.
O the citizens sleep,
their world groggy with
ignorance,
but I hold vigils all night.
Who understands these dark passions?
Wet with Shyam's love,
how could I sleep?
When it rains
does anyone drink from the gutter?
Mira says, Friend,
take this lost child.
At midnight she goes out half mad
to slake her thirst
 at his fountain.

.

bidha bidhaṇā rī ṇyārāṃ

*C*rooked fate,
 crooked decree!
Look at the gentle-eyed deer
condemned
to wander the badlands.
It's crooked! A bright colored heron
that speaks with a rasp
while the articulate
cuckoo is charcoal!
Mira says look around you,
it's twisted—
thieves sit like kings
and our ablest scholars flee into exile.
Even the beggars of God
are made outlaw.

.

kāṃī mhāro jaṇama bārambār

*W*hy life,
 why again,
 and what reason birth as a woman?
 Good deeds in former lives they say.
 But—
 growth, cut, cut, decline—
 life disappears second by second
 and never comes back,
 a leaf torn from its branch
 twists away.
 Look at this raging ocean of life forms,
 swift, unappeasable,
 everything caught in its tide.
 O beloved, take this raft quickly
 and lead it to shore.

.

lagaṇ mhārī syām sūṃ lāgo

This is the seal of
dark love—
that my eyes should thrill with a vision.
My friend, I put on a bride's decorations
that my lover come quickly.
He is no
desolate man,
coming to birth only to perish.
I take the Dark One to bed!
He sates Mira's desire,
life after life
she awaits his arrival.

.

thāro rūpa dekhyāṃ aṭakī

𝒜 glimpse of your body
　　has hooked me!
　　My family sets out their restraints
　　but I'll never forget
　　how the peacock-plumed dancer embraced me.
　　I'm loggy with Shyam,
　　people say—she meanders!
　　Yes Mira's hooked.
　　She goes into depths
　　where every secret is known.

.

sakhi mhāṃro sāmariyā ṇai

*F*riend, I see
 only the Dark One,
 a dark swelling,
 dark luster,
 I'm fixed in trances of darkness.
 Wherever my feet
 touch soil I am dancing.
 O Mira stares into darkness,
 she ambles the back
 country roads.

.

badalā re the jala bharyā ājyo

*C*ome to me, cloud
 bursting with water.
 O secret friends
 a drumming of rain, but listen—
 the cuckoo is crying!
 Thunderbolt music,
 fresh wind,
 ply after ply of cloud in the heavens.
 Today my lover arrives
 and I beg you to sing for him.
 Mira's beloved
 won't perish—
 simply to look at him
 is more wealth than
 anyone needs.

.

josirā ne lākh badhāyā

*T*en thousand thanks
 O astrologer
 for announcing the Dark One's arrival!
 Dizzy, ecstatic,
 my soul goes into her bedroom.
 Five companions converge,
 five senses,
 to give him unparalleled pleasure.
 One glimpse of his form
 dispels anguish,
 all my erotic longings bear fruit.
 Shyam, the ocean of pleasure,
 has come into me.

.

nenāṃ lobhāṃ āṭakāṃ

Wolfish eyes fixed on the Dark One,
 hungry, restless,
 scouring every inch of his body.
 When he came into view
 smiling faintly,
 lit up with moonlight,
 I nearly collapsed by the door.
 My family speaks of their plans
 to restrain me
 but my eyes flash through every obstruction.
 Don't they know somebody's bought me?
 I lift to my forehead
 every word uttered,
 some ugly, some tender—
 without the Dark One's approval
 nothing survives.

jāṇyām ṇa prabhu milaṇa

*I*t's a curse—
 I don't even
 know how to greet him,
 when he slipped through the courtyard
 I blew it.
 Days and nights
 searching for love on the roadways,
 and when it comes through the
 courtyard I'm sleeping.
 Rejected, bewildered, on fire inside,
 Mira wakes up
 and everything's ruined.
 Dark One it's slavery—
 touch me once,
 you won't get away.

.

māi mhāṃ govinda guṇa gāṇā

\mathcal{I} will sing out his beauties!
 So what if the king goes into a fury?
 I can leave his domain
 but anger the Dark One
 where do I go?
 Mira's in-laws delivered a cupful of poison
 but I drank up ambrosia—
 they concealed a black cobra in a wickerwork basket,
 but I found a black precious stone.
 O crazy Mira,
 she's taken the Dark One
 off to her bridal bed!

Note: The "black stone" or *shalgrama* is a fossil ammonite that has been tumbled smooth by glacial runoff. Found along the Gandaki River north of Patna, it is worshipped as a form of Vishnu.

.

jāṇām re mohaṇā

I've tasted it, Drunk One,
 tasted your passion!
I follow the path of romance and worship
and observe no other practice.
You plied me with sweets, now you give poison.
What is this teaching?
Mira's lord cannot perish,
 he befriends whomever he chooses.

.

ab to nibhāyāṃ

Take my arm
 and keep to your promise!
 They call you the refugeless refuge,
 they call you
 redeemer of outcasts.
 Caught in a riptide
 in the sea of becoming
 without your support I'm a shipwreck!
 You reveal yourself age after age
 and free the beggar
 from her affliction.
 Dark One, Mira is clutching your feet,
 at stake is your honor!

.

prabhu ji them kahām gayā

*H*aving wet me with love
 why did you leave?
 You abandoned your unwavering consort
 after lighting her lamp-wick;
 call her a raft
 set to drift on an ocean of craving.
 Either way Mira's dead
 unless you return.

.

holī piyā bina lāgāṃ rī khārī

\mathcal{H}ow bitter is carnival day
 with my lover off traveling.
 O desolate town,
 night and day wretched,
 my small bed in the attic lies empty.
 Rejected and lost
 in his absence, stumbling under
 the pain.
 Must you wander
 from country to country? It hurts me.
 These fingers ache
 counting the days you've been gone.
 Spring arrives
 with its festival games,
 the chiming of anklets, drumbeats and flute,
 a sitar—
 yet no beloved visits my gate.
 What makes you forget?
 Here I stand begging you, Dark One
 don't shame me!
 Mira comes to embrace you
 birth after birth
 still a virgin.

.

acche mīṭhe cākh cākh

The plums tasted
 sweet to the unlettered desert-tribe girl,
 but what manners! To chew into each!
 She was ungainly,
 low-caste, ill mannered and dirty,
 but the god took the
 fruit she'd been sucking.
 Why? She knew how to love.
 She might not distinguish
 splendor from filth
 but she'd tasted the nectar of passion.
 Might not know any Veda,
 but a chariot swept her away.
 Now she frolics in heaven, passionately
 bound to her god.
 The Lord of Fallen Fools, says Mira,
 will save anyone
 who can practice rapture like that.
 I myself in a previous birth
 was a cow-herding girl
 at Gokul.

..........

tero maram nahiṃ pāyo re

𝒴ogin, I did not touch
your intimate secret.
Taking a mystical posture I sat
in a cave,
beads at my throat, limbs pasted with ash.
I had raptures over the Dark One, but no—
I never touched
his imperishable secret.
What Mira obtains
has been written by fate.

· · · · · · · · · ·

jogiyārī prītarī

*T*ake a yogin
 for lover, get nothing but grief.
 He beguiles you with intimate whispers—
 all worthless.
 Sister, he plucks your flower
 like a sprig of jasmine,
 then pulls on his robe and is gone.
 Mira says, Dark One,
 I saw you once,
 but tonight I'm an utter wreck.

.

ho gaye syāma dūija ke candā

*O*ver the trees
 a crescent moon glides.
 The Dark One has gone to dwell in Mathura.
 Me, I struggle, caught in a love noose
 and yes,
 Mira's lord can lift mountains
 but today his passion
 seems distant and faint.

.

koi kachū kahe mana lāgā

*L*et them gossip.
 This mind never wavers.
 Love fixes my mind on that enchanter of minds
 like sorcery fixes on gold.
 Birth after birth lost in sleep
 until hearing the teacher's
 word I awoke.
 Mother, father, clan, tribe—
 snapped like a thread!
 Mira's lord can lift mountains,
 he has aroused her.

.

māi mhāre supnā māṁ

In my dream, sister,
the Lord of the Downtrodden wed me.
Deities danced in attendance,
fifty-six million,
the Dark One was groom in my dream.
In my dream were arched marriage gateways,
a clasping of hands, sister.
In a dream
the Lord of the Downtrodden
married Mira and took her to bed.
Good fortune from previous births
comes to fruit.

.

heli mhāṃsūṃ hari bini

ℱriend, without that Dark raptor
 I could not survive.
 Mother-in-law shrills at me,
 her daughter sneers,
 the prince stumbles about in a permanent fury.
 Now they've bolted my door
 and mounted a guard.
 But who could abandon a love
 developed through uncounted lifetimes?
 The Dark One is Mirabai's lord,
 who else could
 slake her desire?

.

jogiyā ne kahajyo

𝒯ake my message
 to that wandering yogin,
 tell him I've worn out my fingers
 counting the days,
 the time has arrived.

 Matting my hair into dreadlocks
 I'll strip off my gown,
 wrap up in tatters
 and take the left-hand path of the wizards.
 Mystical earrings, charmed necklace,
 ratty old beggar's robe,
 I'll deck myself out,
 skull in my hand for a food bowl.

 I'll wander savage countries
 because you, the protector of girls,
 knocking around faraway cities these days,
 give no protection.
 Mystical earrings, anchorite beads,
 dead man's skull in my hand,
 O crazy yogini, Mira—
 roaming the ages, hunting you down!

Time and again
you promised you'd come when the rains came,
a handful of
pledges all worthless.
Look at my fingers
calloused from counting the days.
I've even turned yellow with anguish,
a grisly look
 for a child.

Mira the slave girl
gave her god prayers,
she might as well give him
 body and mind.

.

maiṁ to teri saraṇa pari

*R*efuge in you, Dark One,
　　you alone
　　know how to save me.
　　A girl possessed,
　　I shamble through the sixty-eight places
　　of pilgrimage
　　but haven't the wit to know failure.
　　Hear my cry, O Murari—
　　nothing on earth
　　looks like it's "mine."
　　Mira gave you her trust, now it's your move.
　　Spring her from this noose
　　　　we call "world."

.

he mā baṛi baṛi aṅkhiyan vāro

*L*isten, friend,
 the Dark One laughs
 and scours my body with ravenous eyes.
 Eyebrows are bows,
 darting glances are arrows that pierce
 a wrecked heart.

You will heal
I'll bind you with magical diagrams
and crush drugs
for a poultice
But if it's love that afflicts you
 my powers are worthless

Sister, how can I heal?
I've already
crushed sandalwood paste,
tried witchcraft—charms and weird spells.
Wherever I go
his sweet form is laughing inside me.
Tear open these breasts
you'll see a torn heart!
Unless she sees her dark lover
how can Mira
 endure her own body?

.

nahim̐ sukha bhāvai thām̐ro desalaṛo

*Y*our colorful kingdom
 just bores me.
 Among your subjects no seekers, O Prince,
 only trash—
 these people are abject!
 Prince Ratan Singh,
 I strip off my jewelry,
 throw down my bangles,
 wipe off eye-black and rouge.
 I shake the barretts from my hair.
 Why? Mira has found
 a lord who lifts mountains,
 a lover who fills her
 completely.

.

rāṇājī mhāne yā badnāmī

*T*his infamy, O my Prince,
 is delicious!
 Some revile me,
 others applaud,
 I simply follow my incomprehensible road.
 A razor thin path
 but you meet some good people,
 a terrible path but you hear a true word.
 Turn back?
 Because the wretched stare and see nothing?
 O Mira's lord is noble and dark,
 and slanderers
 rake only themselves
 over the coals.

.

ḍāri gayo manamohana

*S*nared me—
and now the Enchanter has vanished!
An overhead tree, a cuckoo is singing,
people play amorous games.
For me it's a death chill,
the Enchanter bewitched me and vanished.
I stumble through woodlands—
fever, rejection—
what's left but a blade for my
throat at Banaras?
O the Caster of Spells does not perish.
But look at Mira,
she dies like a slave.

· · · · · · · · · ·

piya biṇa rahyāṃ ṇa jāyāṃ

*U*nable to live since
 he left,
 heart, body, breath given up.
 Day and night a
 ghost on the highway
 lured by remembrance of beauty.
 Lifting her throat
 Mira the slave girl cries out:
 Fetch me home!

.

bhai hom bāvari sun ke bāṃsuri

 Gone mad, sister,
 my lover's departed, but listen—
 a flute!
 O whirling senses,
 O heart reckless and tangled and mad!
 What sort of flute
 works this uncanny priestcraft?
 Even Mira's lord can't untangle this snare,
 the power of seven
 musical notes.

.

mere priyatama pyāre rāma kūṃ

I scrawl
 endless letters and send them
 to Shyam.
 Why does he hold this
 deliberate silence?
 Night after night no reply.
 Sweeping the walk every day,
 wrecking my eyesight
 watching the road,
 when will he come, that Dark One?
 We were lovers in a previous
 life.

.

āvo manamohana jī

O sweet tongue'd Enchanter,
I was a child.
You paid no attention to my
little girl love,
then you vanished.
Bewitched, jerked here and there,
I stumble about,
contradictions eating my heart.
Don't you get it? Mira is yours.
One word, sweet tongue'd Enchanter,
I'll tell everyone,
I'll beat it out
on my drum.

For Love Of The Dark One

karaṇāṃ suṇi syām meri

*H*ear my plea, Dark One, I am
 your servant,
 a vision of you has driven me mad.
 Separation eats at my limbs.
 Because of you
 I'll become a yogini and ramble
 from city to city
 scouring the hidden quarters—
 pasted with ash, clad in a deerskin
 my body wasting
 to cinder.
 I'll circle from forest to forest
 wretched and howling—
 O Unborn, Indestructible,
 come to your beggar!
 Finish her pain and touch her
 with pleasure!
 This coming and going will end,
 says Mira,
 with me clasping your
 feet forever.

.

saiyāṃ tum viṇi ninda na āvai

*D*ark One,
 how can I sleep?
 Since you left my bed
 the seconds drag past like epochs,
 each moment
 a new torrent of pain.
 I am no wife,
 no lover comes through the darkness—
 lamps, houses, no comfort.
 On my couch
 the embroidered flowers
 pierce me like thistles,
 I toss through the night.

 Yet who would believe my story?
 That a lover
 bit my hand like a snake,
 and the venom bursts through
 and I'm dying?

For Love Of The Dark One

I hear
the peacock's faraway gospel,
the nightingale's love song,
the cuckoo—
thickness on thickness folds through the sky,
clouds flash with rain.
Dark One, is there no love
in this world
that such anguish continues?
Mirabai waits for a
 glance from your eye.

.

mīrāṃ lāgau raṅga harī

*T*he Dark One's love-stain
 is on her,
 other ornaments
 Mira sees as mere glitter.
 A mark on her forehead,
 a bracelet, some prayer beads,
 beyond that she wears only
 her conduct.

Make-up is worthless
 when you've gotten truth from a teacher.
 O the Dark One has
 stained me with love,
 and for that some revile me,
 others give honor.
 I simply wander the road of the sadhus
 lost in my songs.

Never stealing,
 injuring no one,
 who can discredit me?
 Do you think I'd step down from an elephant
 to ride on the haunch
 of an ass?

.

letāṃ letāṃ rāma nāma re

*S*hame would kill
 these people
 if anyone heard them speak a true word.
 They dash
 from here to there in the village
 but complain they're too tired to visit a temple.
 A fight breaks out
 they storm off to watch it;
 a busker starts jesting,
 a whore dances,
 the townsfolk sit laughing for hours.
 But Mira sits somewhere else—
 at the lotus feet
 of her Dark One.

.

prabhu so milana kaise hoy

When can I meet
the Dark Lord?
Caught up in duties fifteen
hours a day,
nine hours absent in sleep.
Human birth, says Mira,
is precious
but we get it and waste it.
Give yourself to the Dark One,
fate never swerves
from its course.

.

yā vraja meṃ kachū dekhyo rī

O I saw witchcraft tonight
in the region of Braj.
A milking girl going her rounds,
a pot on her head,
came face to face with the Dark One.
My friend, she is babbling,
can no longer say "buttermilk."
Come get the Dark One, the Dark One!
A pot full of Shyam!
In the overgrown lanes
of Vrindavan forest
the Enchanter of Hearts fixed his
eye on this girl,
then departed.
Mira's lord is hot, lovely
and raven—
tonight she saw witchcraft
at Braj.

· · · · · · · · · ·

koī syāma manohara lyorī

*S*tumbling about,
 a clay pot on her head,
 the word for
 buttermilk gone from her tongue—
 Who will take darkness, the Taker of Hearts?
 Come take the taker, the taker!
 The milking girl's lost in a
 dark body seizure,
 her mouth full of garble.

.

māī rī mhā liyāṃ govindāṃ mol

\mathcal{S}ister,
 I went into market
 and picked up the Dark One.
 You whisper
 as though it were shameful,
 I strike my drum and declare it in public.
 You say I paid high,
 I say I weighed it out on the scales,
 it was cheap.
 Money's no good here,
 I traded my body, I paid with my life!
 Dark One, give Mira a glance,
 we struck a bargain
 lifetimes ago.

.

papaiyā re piva kī vāṇi

𝒟 readful cuckoo
who said you could sing about love?
A girl like me
might twist off your wings in a fury,
rip out your beak,
pour salt on the wounds.
The Beloved is mine,
 your song to him is an outrage!

Yet if today
the Dark One showed up
I'd weep with delight at your tune,
you'd be my companion,
I'd paint gold
 on your beak.

Look—
I've drafted a letter,
fly to him quickly,
say the girl he rejected's quit eating,
won't sleep,
goes into fits—
that every dawn Mira sings
to her Dark One:
Come quickly,
 your absence destroys me.

For Love Of The Dark One

.

kiṇa saṅg khelūṃ holī

*T*errible solitude
 festival day
 now that he's gone.
 Damn these rubies and pearls,
 I'll string devotional beads
 at my throat.
 And here's an old hermit cloak—
 now that food and house
 are distasteful
 it matches my feelings.
 What makes me like this?
 It's a riddle.
 You take me to bed
 then go off and fuck
 some other girl.
 Does she have you under her spell
 that you can't even write me?
 Mira's a bundle of nerves in your absence.
 Look at her,
 an unwatered weed when the
 Dark One's away,
 she wilts in the rubble.

.

jāgo baṃsīvāre lalanā

*W*ake up,
my lover of women,
my amorous fluteplayer,
night has fled,
it is dawn.
Shutters bang open in house after house.
Hear the bracelets
chiming together
as *gopis* strain at their butter churns.
Wake up, it is dawn,
gods and men
throng through the doorways,
cowherding boys,
their little hands stuffed with bread and butter,
drive cattle to pasture.
Wake up! Mira says:
The fluteplayer will save you,
but you must come
seeking refuge.

.

māī mero mohane maṇa haryo

*S*ister, the Enchanter
has stolen my heart.
Where can I go,
what can I do—
he took the breath from my lungs.
I'd gone to the river
a jug on my head
when a figure rose through the darkness.
Sister, it cast a sorcerer's noose
and it bound me.
What the world calls virtue suddenly vanished.
I performed a strange rite.
Mira may be a slave, Sister,
but she herself
 chose whom to sleep with.

.

kahāṃ kahāṃ jāūṃ tere sāth

\mathcal{D}ark One
 where are we going?
 The groves and alleys of Vrindavan forest
 had folded around us,
 abruptly the Enchanter embraced me.
 He drank up my curds
 and shattered the earthenware pot.
 With a blaze
 of fragrance and darkness
 he snatched my earthenware jug
 and broke it apart.
 Where are we going, Dark One,
 why this confusion?
 You come and you go through Gokul,
 rejecting my gifts,
 yet you are the lord
 who heaps birth upon birth.

.

syāma bina duḥkha pāvāṃ sajaṇī

He's gone
 friend, and I suffer.
 Whatever I cling to dissolves.
 This drifting world's a
 turbulent cauldron,
 it leaves nomads of truth without shelter.
 Seekers get mocked,
 people act rashly,
 they fling themselves into infernos
 and no one gets free—
 just the churning
 of eight million wombs.
 Groping,
 at every turn twisting,
 missing the passage towards freedom.
 Mira says, Dark One,
 we call refuge in you
 "the beyond."

.

āj mhāṃro sādhu janano saṅgare

𝒢ood fortune
 my Prince,
 today I went among sadhus!
 Coming and going
 I tasted their splendor four times.
 But Goddess cults—
 shun them—
 they'll wreck your devotion!
 Forget the fashionable visits
 of pilgrims,
 Banaras and Ganges are found
 at a holy man's feet.
 Don't mock the seekers,
 you'll be dipped
 in a hell pool,
 go crippled, go blind.
 Yes Mira's lord can lift mountains,
 today she covered her body
 with dust from a
 holy man's feet.

.

papaiyā mhārī kab rau

*W*hy this impulse
 to hurt me, O cuckoo?
 I was in my own
 hut asleep
 when you cried out a love song,
 rubbing salt in the wound.
 There you sat
 high on a tree branch
 singing from deep
 in your throat.

.

bhije mhāṃro dāṃvan cīr

*O*ut in a downpour
 in a sopping wet
 skirt.
 And you have gone to a distant country.
 Unbearable heart,
 letter after letter
 just asking when,
 my lord, when
 are you coming?

.

miltā jājyo ho jī gumānī

*C*ome, O aloof one
 a glimpse of
 your body has caught me.
 My name?
 Call me the girl
 who separation drove mad.
 Night and day there's a fish
 thrashing
 next to the water,
 servant Mira dies at your feet—
 and she calls you the
 Giver of Joy.

·········

giradhara rīsāṇā kaun guṇāṃ

W hat is this anger
 from one who lifts mountains?
 Did I fail you,
 affront you?
 Dropping through womb
 after womb
 servant Mira returns,
 calling your name
 every time.

.

jhaṭakyo meri cīr

*M*urari yanked
 at my skirt,
 the clay pot of indigo bounced
 from my head,
 my sari snagged on my
 nose ring,
 hair knot slipped loose,
 earrings got tangled—
 the Dark One makes love an art of
 enchantment—
 I lower my head
 to his feet.

.

premani premani pramani re

\mathcal{P}assion,
 passion's the dagger that
 savaged this heart.
 I'd gone to Jamuna River
 a gold pot on my head.
 The Dark One tossed out a thread,
 bound me,
 and led me along.
 O I see darkness,
 unspeakable beauties,
 now I see omens.

.

mhāro maṇa sāṃvaro

O creatures of earth,
 I wiped out ten million ignorant deeds
 by calling on Shyam,
 his name revolves in my heart.
 Countless vile births
 countless ancient depravities
 drained like a
 cup of sweet juice.
 Mira's lord does not perish,
 he wipes out evil karma,
 body and mind.

.

matavāro bādara

*D*runk, turbulent clouds
　roll overhead
　but they bring from the Dark One
　no message.
　Listen!
　the cry of a peacock,
　a nightingale's faraway ballad,
　a cuckoo!
　Lightning
　flares in the darkness,
　a rejected girl shivers,
　thunder, sweet wind and rain.
　Lifetimes ago
　Mira's heart went with the Dark One,
　tonight in her solitude
　infidelity spits
　　　like a snake—

Glossary

Banaras—Varanasi, India's holiest city. The aged, ill and infirm have for millennia traveled to Banaras, to die—to depart from one of the burning *ghats* or landings that line the banks of the Ganges River. Orthodox Hindus believe that to die in Banaras delivers you immediately to heaven. A commentator notes that in Mirabai's day special saw blades were available in Banaras, on which people suffering from spiritual despair could slice their own throats, assuring themselves a congenial rebirth.

bhakta—Devotee, or lover of God. One might also say "beggar" of God. The term etymologically suggests a person who gives or receives a share or portion from God.

bhakti —Devotion. The *bhakti marg* is the path of worship, *bhakti* poetry a verse of devotion. A popular reaction against tight religious control exercised by priests and ritualists, *bhakti* appeared first in south India around the tenth century, took fire as a spiritual and cultural revolution, and spread rapidly into the north. By Mirabai's day there already existed a visible body of

practitioners who drew from both Hindu and Sufi spiritual traditions.

Braj—A region in eastern Rajasthan where Krishna spent his childhood among cowherds. Vrindavan forest lies here—the woods where the Dark One played amorous games as a youth, and where Mirabai went in search of him when she fled her palace home.

Gokul—A village of rural cowherding people on the banks of Jamuna River, associated in legend with the childhood of Krishna. It is here that the gopis first fall in love with Krishna and become his beloved devotees.

gopi—"Cow-herding girl," associated with legends of the amorous Krishna. The *gopis* fall recklessly in love with their god, whose midnight flute music maddens them, drawing them forth from their homes and husbands, to dance and make illicit love in the forest groves. Theirs is a circle dance, a perilous one because Krishna who moves at the center is not husband but lover. Discovery is a constant threat; thus the dance becomes not only symbolic of an erotic mysticism, but an emblem of the fearsome risks the human spirit must undergo to encounter the divine.

Hari—"Seizer" or "Abductor," an epithet of Krishna. The pious call on him to "seize away" their sins. The reckless *bhakti* poets cry out for him to seize them utterly, body and mind.

Jamuna River—One of India's sacred rivers, particularly associated in legend with Krishna.

Mathura—City along the Jamuna River in present-day Uttar Pradesh. It lies in the region of Madhuban, "Forest of Sweet Delight," within which the Dark One is reported to have taken up residence, and to which Mirabai pursues him after fleeing her homeland in Rajasthan. The teachings of the Tantrikas suggest also the existence of an inner Mathura, a spiritual condition.

Murari—"Slayer of Mura," an epithet of Krishna who according to legend killed Mura, a demon that terrorized villagers in the region in which he grew up.

sadhu—"Going straight to the goal or target," said of an arrow. A spiritual seeker, generally a homeless wanderer. This is a man or woman (*sadhvi*) who has surrendered caste, family, name, and material comfort in order to ramble the pilgrimage routes of India, visit the holy sites, beg the small amount of food necessary, and devote his or her life to spiritual or magical pursuits. A *sadhu* often undergoes dramatic and dreadful asceticisms, and can be recognized by their tattered orange (saffron) robes, begging bowl, and hair matted with cow-dung or crematory ash. Certain sects have used a human skull for begging bowl.

Shyam—The Dark One, the "Raven Colored." This color of black, like the word *krishna*, denotes a glossy, lustrous black. In paintings of Krishna one can see a tensile aura of blue. It is

reflective, attractive, lifegiving, in contrast to the black-hole, the absence of color associated with Kali, which gives off no light at all.

Veda—The ancient texts of Hinduism, dating from the second millennium B.C.E., which make up the liturgical and philosophical wisdom of the brahmin priests. An entrenched priesthhood had, by Mirabai's time, come to regard mastery of the Veda as the only legitimate path to spiritual illumination. The bhakti movement arose in part as a reaction against this dogmatic, literalist approach to religion.

yogin, yogini—A practitioner of one of the numerous forms of spiritual asceticism (*yoga*) in India. The term is used indiscriminately for contemplative saints, devotees, anchorites, wizards and sorcerers. *Yogin* is the masculine form, *yogini* the feminine. The spelling *yogin* accurately reflects the Sanskrit, while *yogi*, though technically inaccurate, has become common in English. In the vernacular languages Mirabai spoke, as well as in modern-day Hindi, phonetic shifts have altered the pronunciation to *jogin* and *jogini*.

References

Translation takes place in a dusk or twilight where two differ-
ent and unequal worlds meet and occasionally collide. The work
of the translator is charged at many levels: linguistic, political,
spiritual. I cannot think of the job without hearing the line from
Yeats, "a terrible beauty is born." When the utterances of one
world crosses into the language of another, powerful distur-
bances occur. Sometimes these are personal, at other times the
political implications are enormous and no one can foresee what
might be aroused. One can only bow one's head and try to pro-
ceed with sensitivity. Poets and translators are couriers on a
delicate mission. No amount of training or experience prepares
you for the work itself.

In offering the following list of books and music, I give two
cautions. The first is that Mirabai is a woman I myself have met
in the twilight reaches of poetic language. She is real. But she
differs radically from the Mirabai others have encountered. My
Mirabai bears little resemblance to the chaste and saintly Hindu
holy woman that comes as an apparition to the pious. She is not
a practitioner of civil disobedience within the context of a Hindu
household, however much the followers of Mahatma Gandhi

may consider her so. She also carries few of the reactionary
lineaments that several feminist critics have challenged. I fail to
see how a woman who wanders the streets with a drum, *sadham
samgamana*—"consorting with sadhus" or "sleeping with
sadhus"—in any way upholds conventional norms of marriage,
in India or anywhere else on the planet. Mira was an educated
woman. The ease with which her poetry handles the discoveries
of 1500 years of Indian poetry, as well as its familiarity with the
language of contemporary Tantrika poets, strongly suggests
she'd studied the principal arts and their languages. She knew
that *samgamana* is one of the commonly met terms in Sanskrit
poetry for sexual pleasure. The dictionaries equate it with
samyoga and *maithuna*. Her use of a playful, sexually provoca-
tive, spiritually precise terminology shows how revolutionary
she was.

For me, Mirabai is first of all a singer, a troubadour, a finder
or maker of songs. Music and speech intertwine in the crepus-
cular realm of her art. My Mirabai has survived for four hundred
years within a context that is more oral than literate, that is
rebellious and nomadic; she lives and sings within a musical and
shamanic counterculture that extends deep into Asia's paleolith-
ic. For this reason, it was only with my head full of her music
that I went to the written texts. I would likewise encourage any-
one who wants to know more about Mira to also go first to the
singers. I have described a number of the recordings that best
reveal her art.

Bibliography

Texts used for this edition:
Caturvedi, Parashuram, ed. *Mirambai ki Padavali*. Allahabad: Hindi Sahitya Sammelan, 1973.

Prasad, Kalika. *Brihat Hindi Kosh*. Varanasi: Jnanamandala Editions, no date.

Shashi Prabha. *Miram Kosh*. Allahabad: Smriti Prakashan, 1974.

Singh, Neelima, ed. *Mira: Ek Antarang Parichaya*. Delhi: Saraswati Vihara, 1982.

English Translations and References:
Alston, A.J. *Devotional Poems of Miarabai*. Delhi: Motilal Banarsidas, 1980. Translations of all 202 poems from the *Mirabai ki Padavali*.

Goetz, Hermann. *Mira Bai, Her Life and Times*. Bombay: Bharatiya Vidya Bhavan, 1966.

Halpern, Daniel, ed. *Holy Fire: Nine Visionary Poets and the Quest for Englightenment.* New York: HarperCollins, 1994.

Harlan, Lindsey. *Religion and Rajput Women.* Berkeley: University of California Press, 1992. In particular her chapter "The Bhakti Paradigm: Mira Bai."

Hawley, John S. and J.M. Jurgenmeyer. *Songs of the Saints of India.* New York: Oxford University Press, 1988.

Levi, Louise Landes. *Sweet On My Lips: The Love Poems of Mirabai.* Brooklyn: Cool Grove Press, 1997.

Martin-Kershaw, Nancy M. "Mirabai: Inscribed in Text, Embodied in Life," in *Journal of Vaishnava Studies,* vol. 3, No. 4, Fall 1995.

Mirabai. (Comicbook). Bombay: India Book House, 1988.

Manushi, nos. 50-52, *Devotional Women of India.* January-June 1989. (This volume contains excellent essays by a range of mostly Indian scholars; also photographs of shrines, images, paintings, record covers.)

Nilsson, Usha S. *Mira Bai.* New Delhi: Sahitya Akademi, 1969.

Sangari, Kumkum. "Mirabai and the Spiritual Economy of Bhakti." In *Economic and Political Weekly,* July 7 and July 14, 1990.

Schelling, Andrew. "'Where's My Beloved?' Mirabai's Prem Bhakti Marg," in *Journal of Vaishnava Studies,* vol. 3, No. 4, Fall 1995.

Schomer, Karine, and W. H. McLeod. *The Sants: Studies in a Devotional Tradition of India.* Delhi: Motilal Banarsidas, 1987.

Singer, Milton, ed. *Krishna: Myths, Rites and Attitudes.* Chicago: The University of Chicago Press, 1968.

Tharu, Susie and K. Lalita. *Women Writing in India, Vol. I: 600 B.C. to the Present.* New York: The Feminist Press at the City University of New York, 1991.

Recordings:

Lakshmi Shankar Sings Mira Bhajans. Ravi Shankar Music Circle #5. (Cassette.)

 Lakshmi Shankar is probably the best known Hindustani singer among American audiences. Her early recordings present a feast of Mirabai, songs both passionate and oddly chaste. She introduces the chastest song attributed to Mirabai as "a favorite of Mahatma Gandhi."

Les Heures et les Saisons: Lakshmi Shankar. Harmonia Mundi (558615/16).

 I find no other recording of Mira quite so ravishing as the two songs included here. Everything conspires on this record to

produce an unparalleled rendition of Hindustani music—the
quality of the recording, the maturity of Lakshmi Shankar's
voice, the attentiveness of the musicians who back her. After the
profoundly difficult and "classical" *khyal*, and the somewhat
lighter *thumri*, Lakshmi Shankar finishes in the traditional
manner, with *bhajans* by Mirabai and Surdas. Tradition consid-
ers these songs "light," not emotionally but musically, and thus
a fitting closure to a long recital. Her *Jogi mata ja* ("Yogin,
don't go...") will seize your heart the way Billie Holiday does.

Chants de dévotion / Chants of Devotion. Lakshmi Shankar.
Auvidis, MC Ethnic B 3745, 1990.
 Also a fine recording, with songs by Mira ("Tumhare
Karana"), Kabir, and Surdas.

Mira Bhajans Sung by S.M.S. Subhalakshmi. The
Grammaphone Company of India. EMI Discs (EALP 1297).
 This is the famous recording of Mirabai, sung by the inter-
nationally known concert hall artist. Referred to as "the most
influential recording of religious music ever made in India," it
exhibits the sort of restraint only the most accomplished musi-
cians can manage—a restraint that permits it to smolder all the
more with Mira's desperate longing for her Dark One.

Meera Bhajans. Kishori Amonkar. EMC.
 Kishori Amonkar, almost unknown in the West, is a fine clas-
sical singer. Her Mirabai versions however take their cue from
Hindi film music, India's popular genre, and are racy, full of
panache and ornamentation. An uncommonly large orchestra

96

backs the singing. While far removed from the traditional methods of interpreting Mira's song, an adaptation of her tunes to modern popular music was inevitable—after all, for four hundred years Mirabai has been "popular." The musicians play, and Kishori sings, with terrific sensitivity to the poems themselves, shifting their moods with swift intelligence. It helps here to know what the lyrics are saying so you don't get swept off by the ornamentation.

Anthologie de la Musique De L'Inde Vol. 2. Alain Danielou. GREM (G 1509).

This collection has only one Mirabai song, but Nandan Prasad's version may be closest to how it has sounded on the streets all these years, a solitary voice accompanied by only two small drums. Dry, austere, ancient—and unutterably devastating. The one recorded performance I've found that gets into its musical changes some of the desert roadway dust through which Mira walked. And sung by a man. In this gender shift there is nothing unusual. "Are not all souls female before god?" asked Mira. The outward man is but a delirium that conceals the inward woman. Hundreds of male singer/poets, spanning India from Gujarat to Bangladesh, assume the woman's role in song and devotion. Among members of certain sects the inner female has utterly devoured the outer man—these men dress, talk, sing and make love as women.

Ma Taru Sings Mirabai. Unreleased tape from the Rajneesh Ashram, Poona.

A privately circulating tape, these versions introduced a talk on Mirabai given by the late international guru Osho, formerly

known as Bhagwan Shree Rajneesh. No instrument, not even a drum to accompany the singer, and though Ma Taru's versions are graced with passion and restraint, she sings for a teacher and audience that go to Mira's songs as to *sutra* or sacred text. Her singing intends a clear articulation of the words, with minimal inweaving of musical or choral elements. Again, this recording derives its beauty from the singer's austerity.

Meera (Bhajans) by Anuradha Paudwal. Umbrella, UMB 058.
Readily found in a large Indian grocery, this is one of many versions produced in the popular *bhajan* tradition, highly influenced by contact with Hindi film music—flutes, electric violin, a string section, cymbals and a sitar. While singer and orchestra stray from the melodic lines made familiar in other recordings, Ms. Paudwal's voice is full of relaxed witchery. Nothing austere or understated about this tape. Though it may sound "light," like popular "covers" of traditional song-lore across the planet, Paudwal's is a serious interpretation; it will savage the unsuspecting heart.

"Chala Vahi Des" & Meera Bhajans by Lata Mangeshkar, EMI, The Grammaphone Co. of India, CDNF 1.53002.
Lata Mangeshar, known for her film music, gives us a Mirabai rendition notable for its dry, gypsy-like flavor. You could call it "barefoot" singing. A few studio tricks get thrown in, but mostly it is Lata's thin, hauntingly austere voice — with a stiff little drum or quiet stringed instrument behind it. This may be close to how Mirabai sounded.